ILLUSTRATED BY François Gautier

EDITED BY

Susannah Bailey

Jade Moore

COVER DESIGN BY

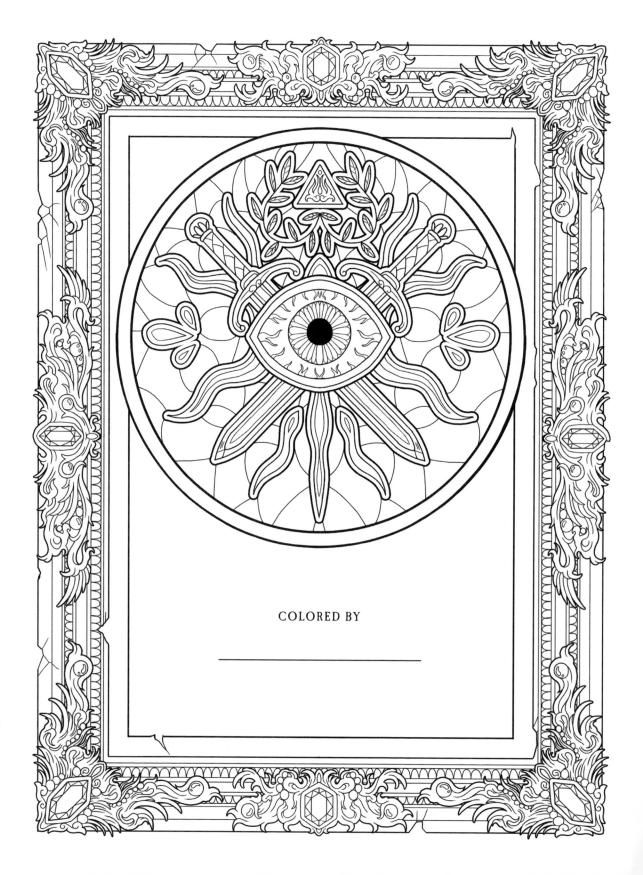

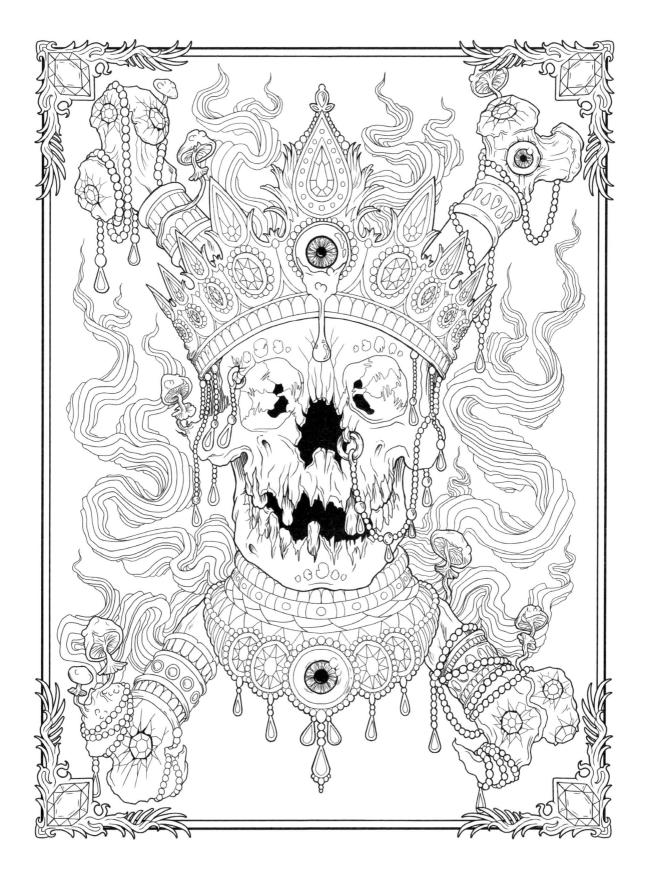

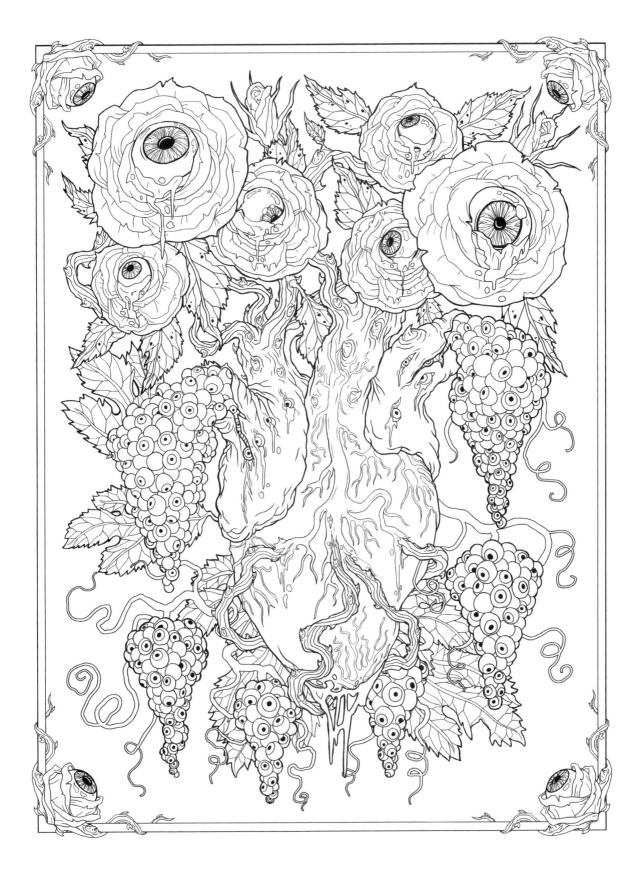

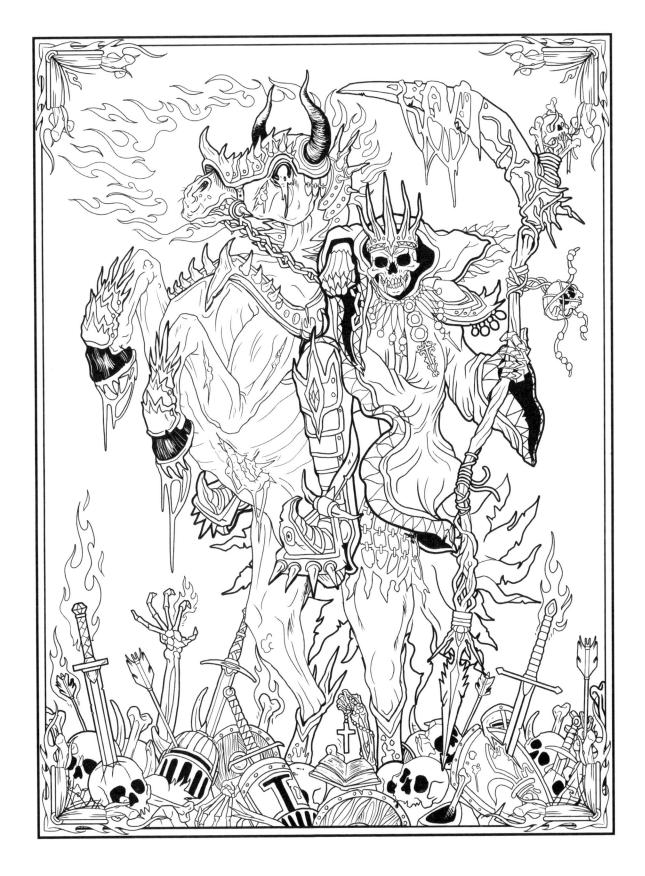

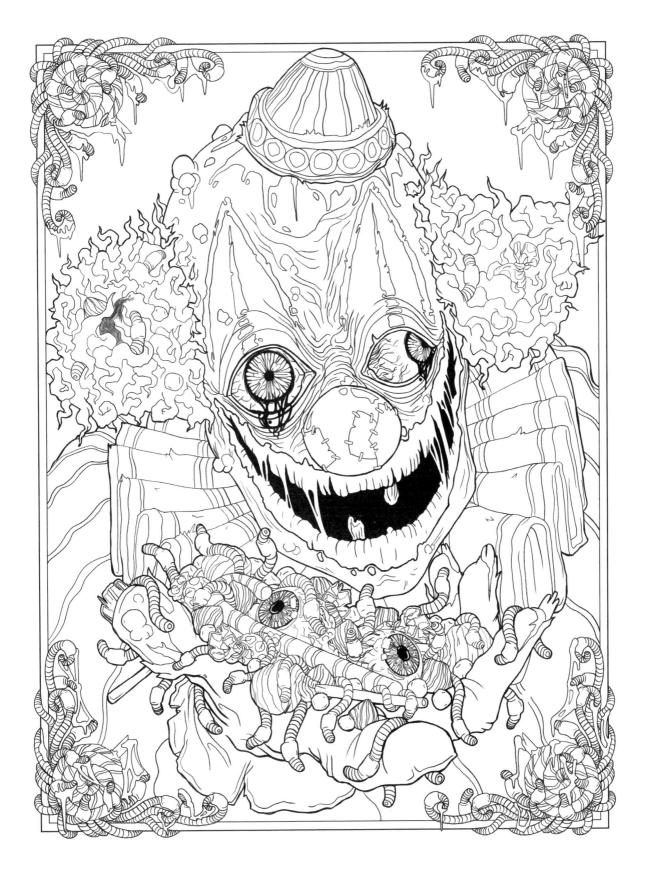

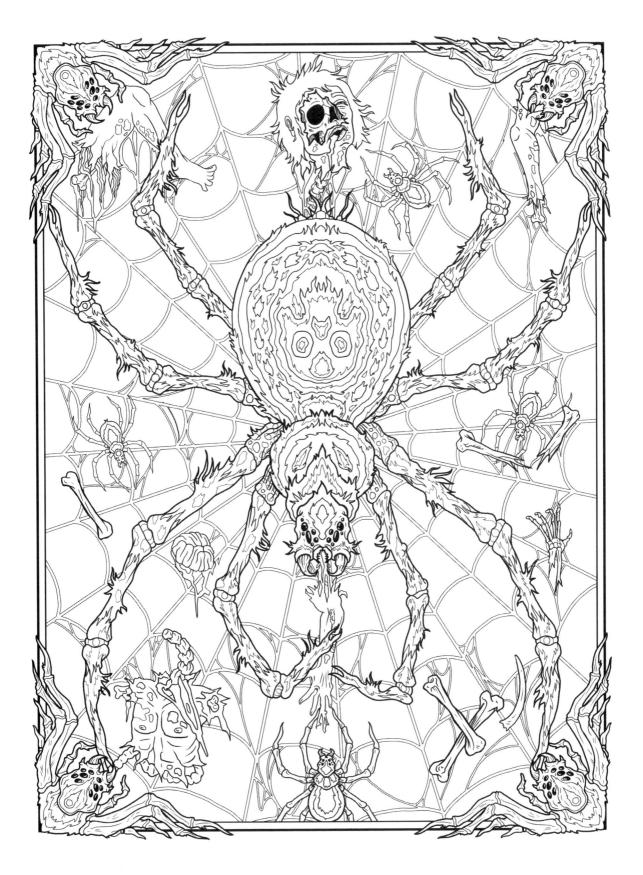

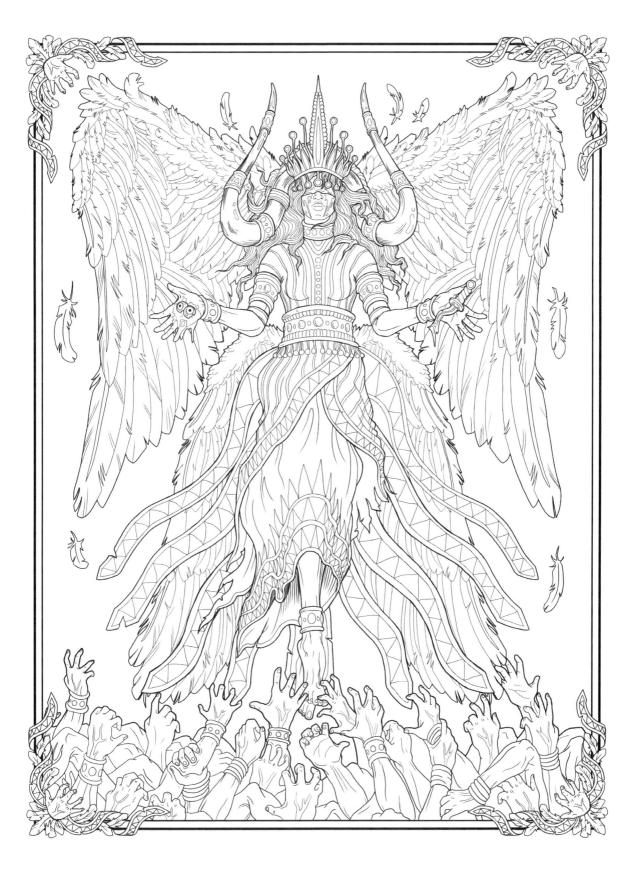

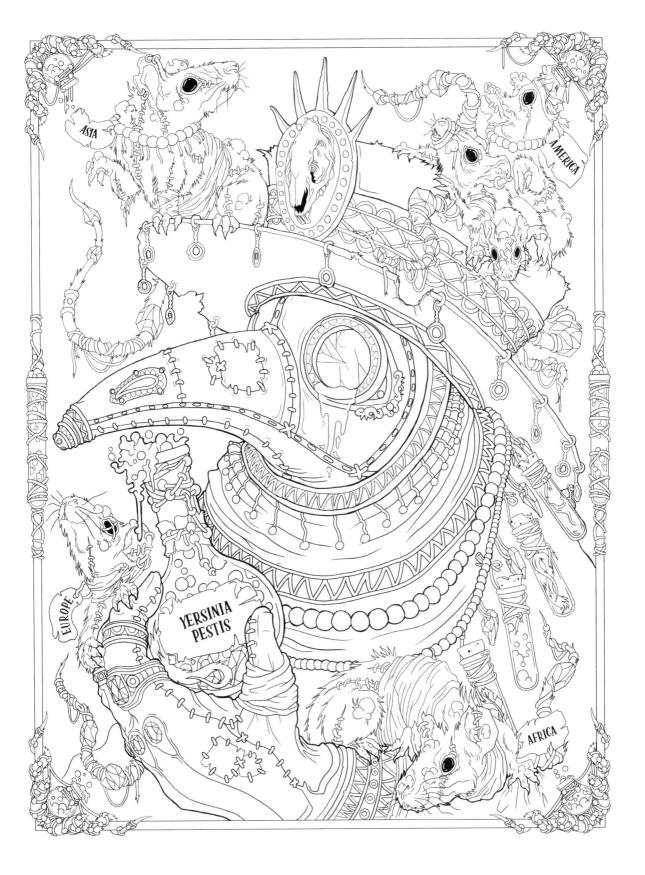

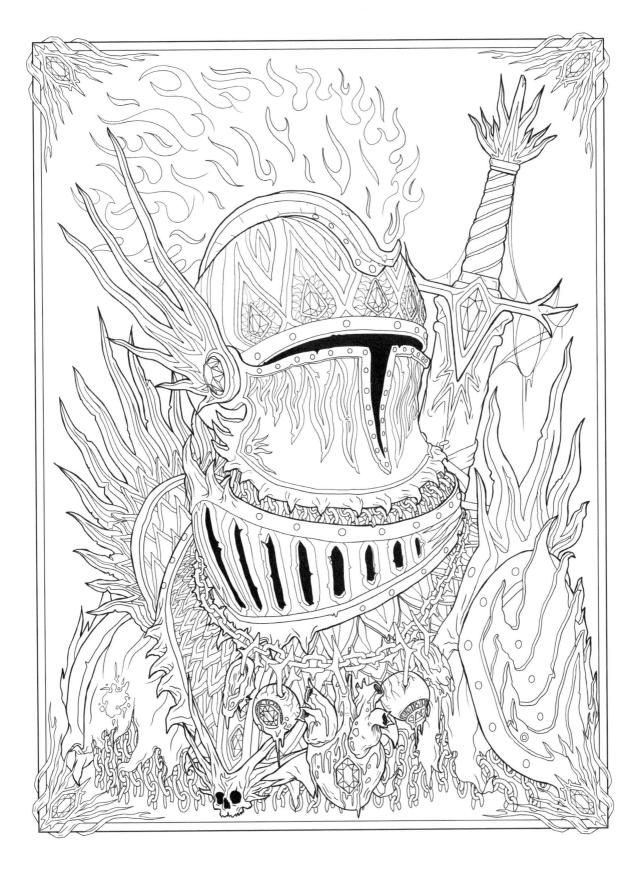

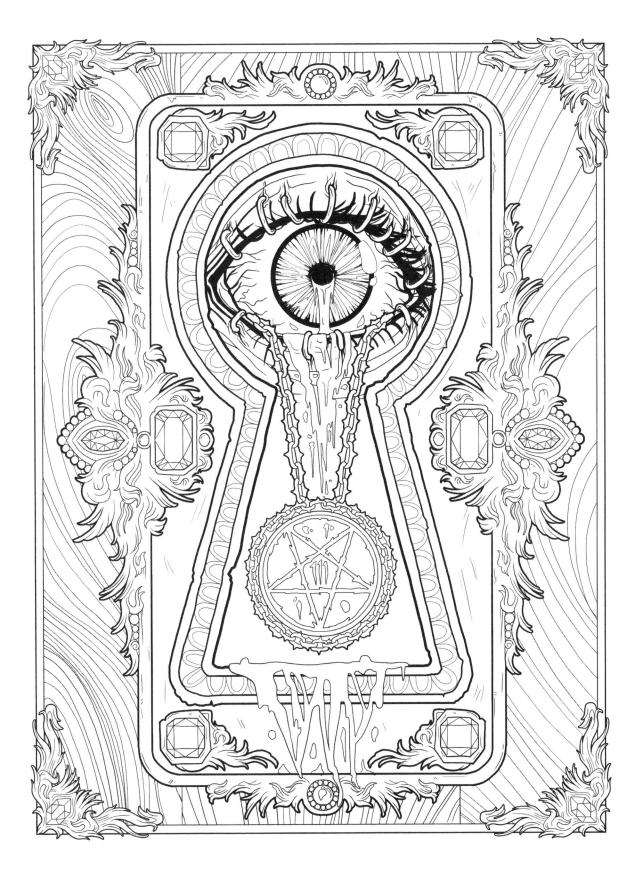

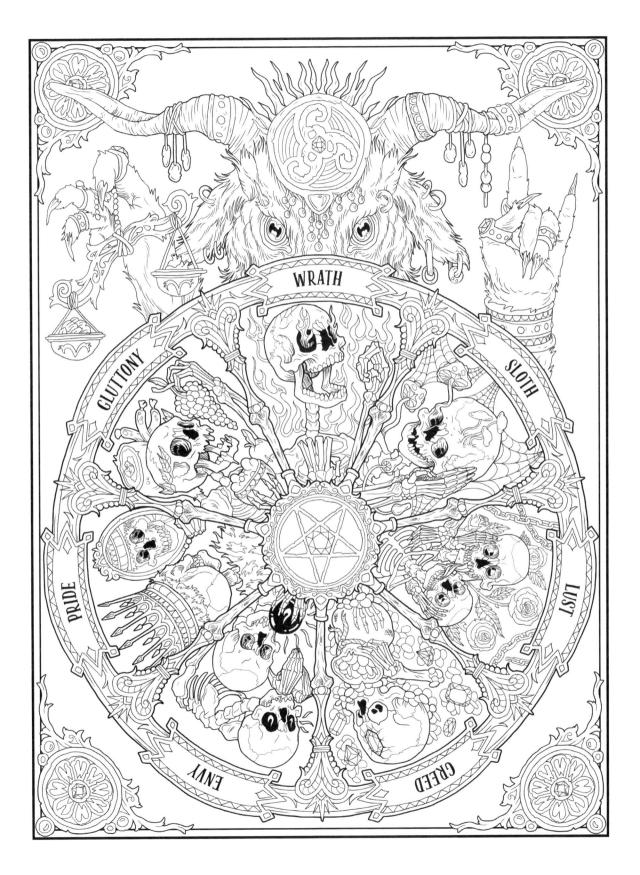

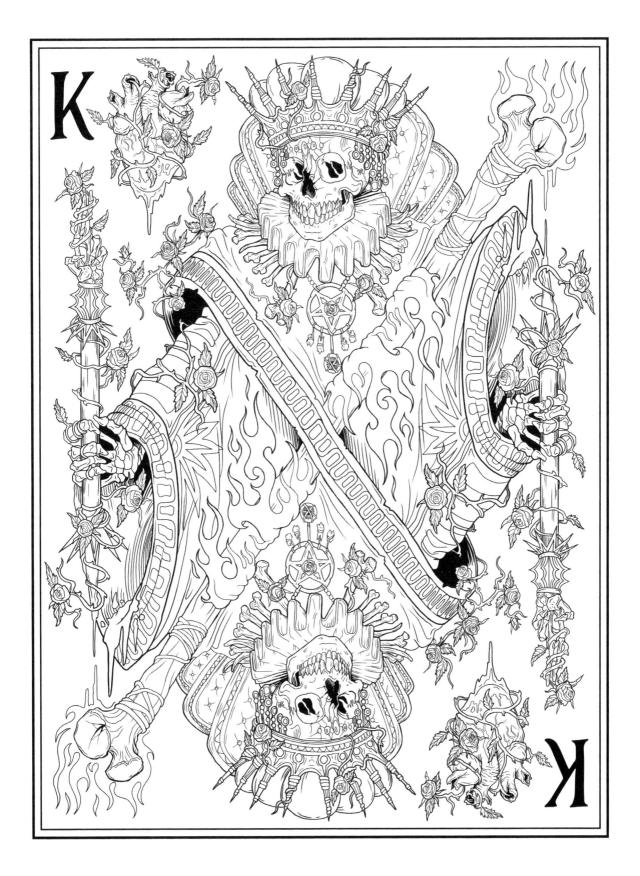

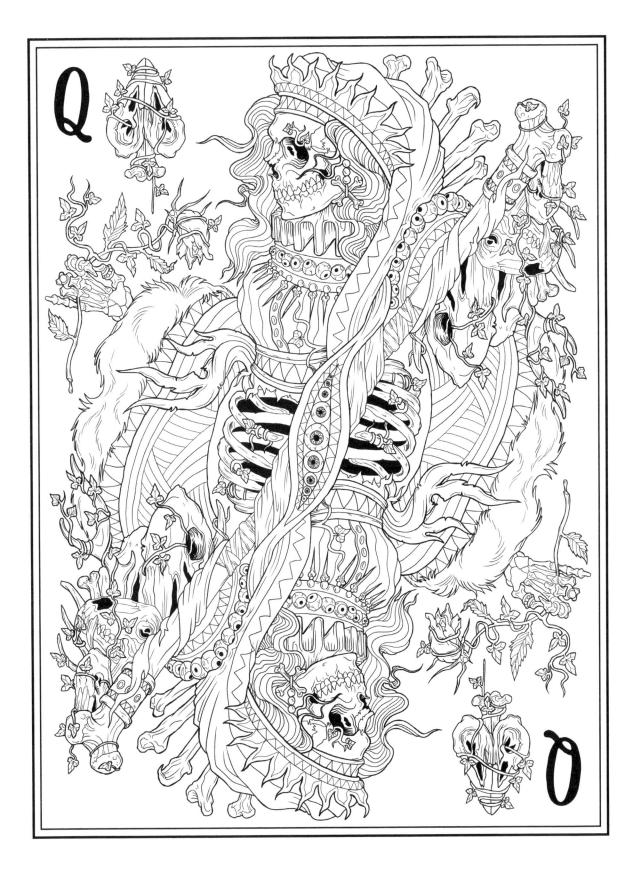

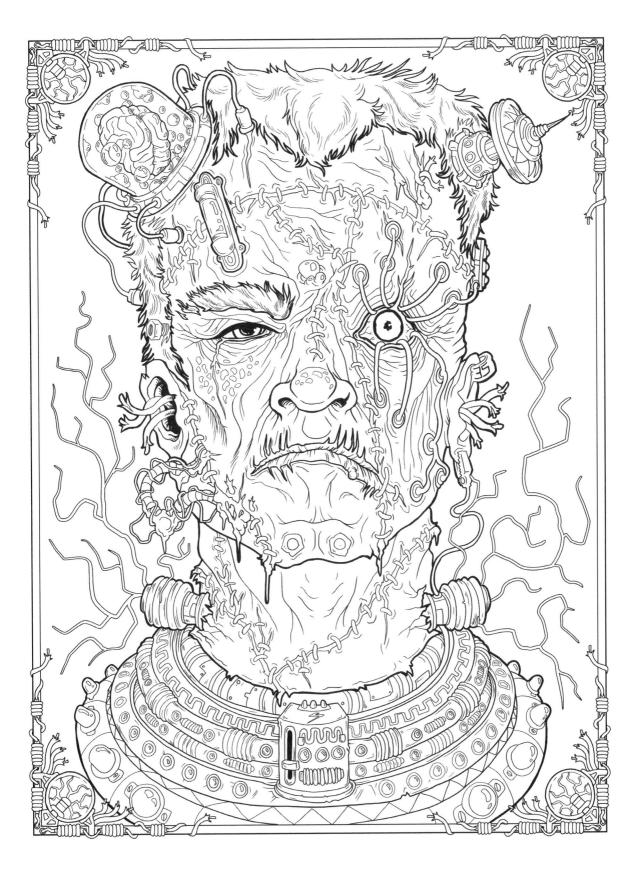

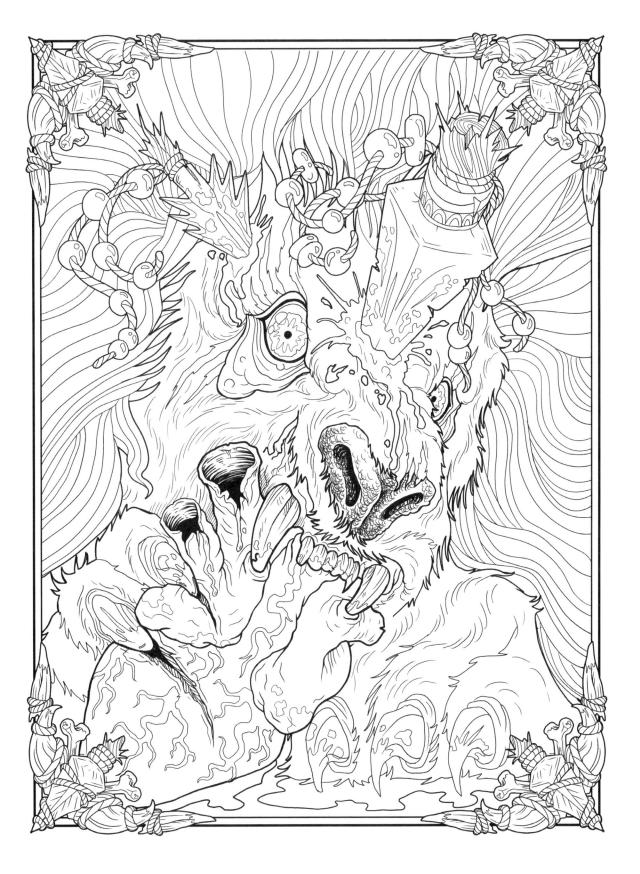

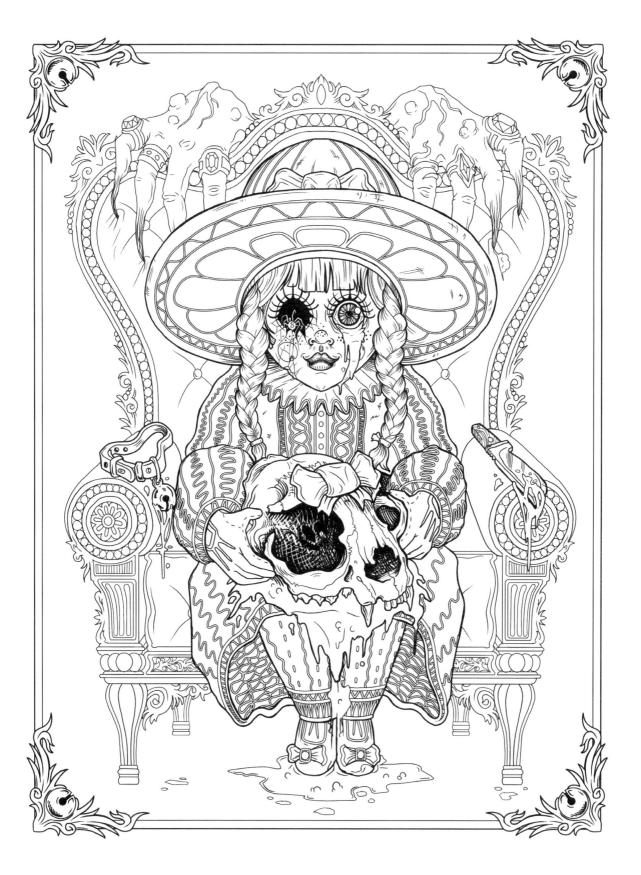

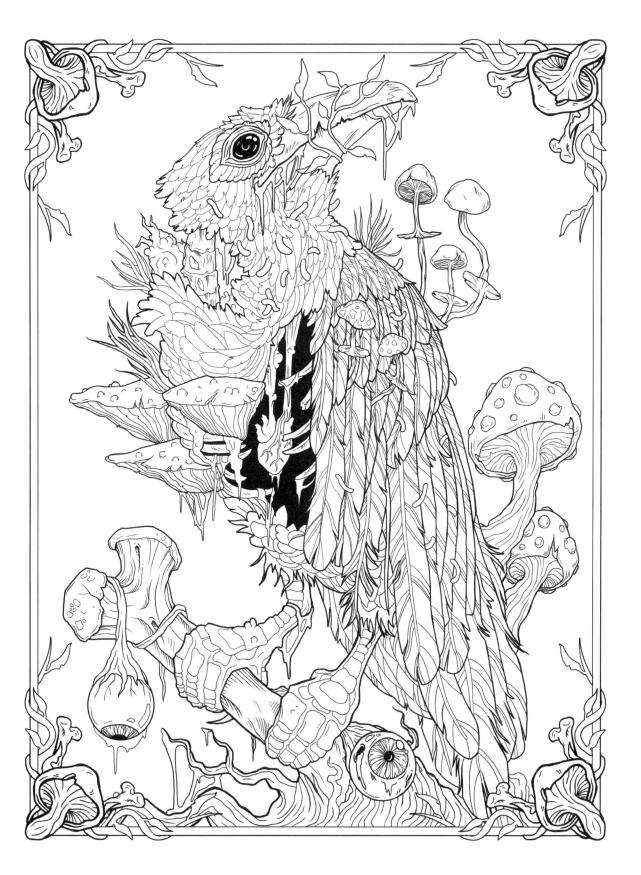

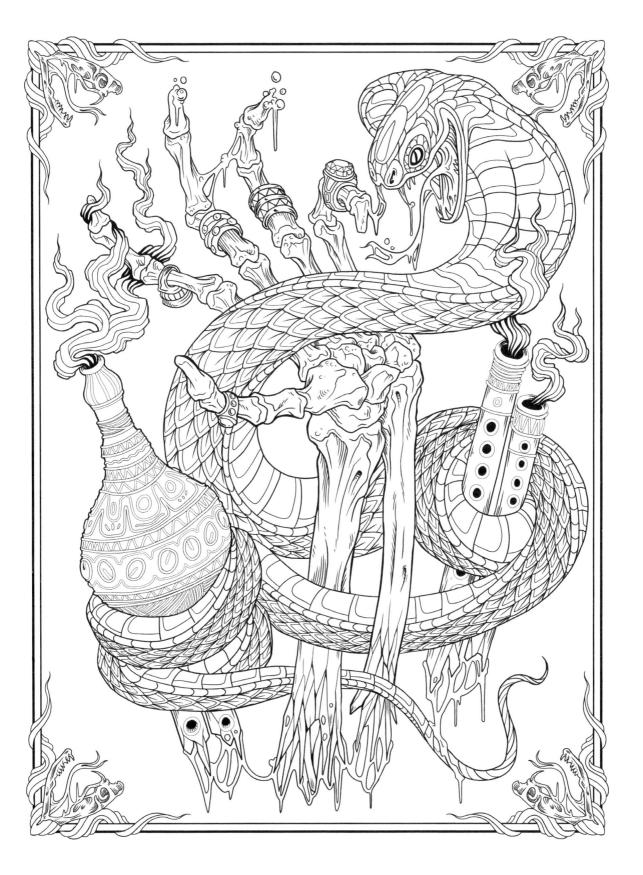

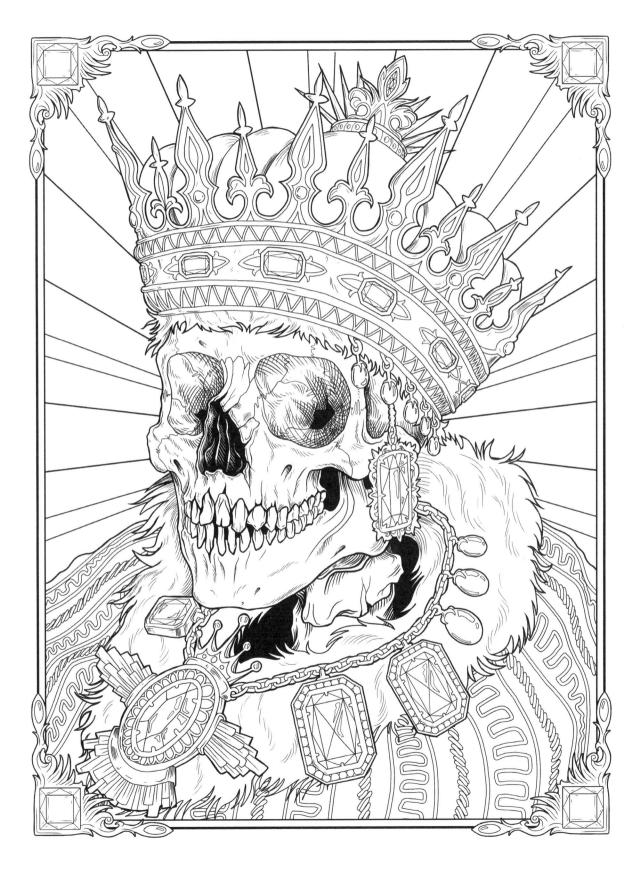

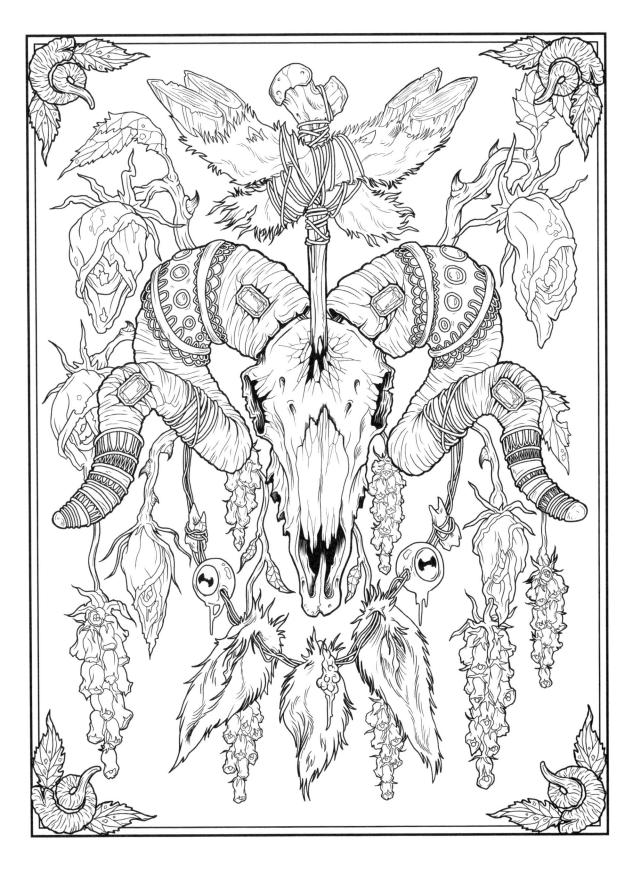

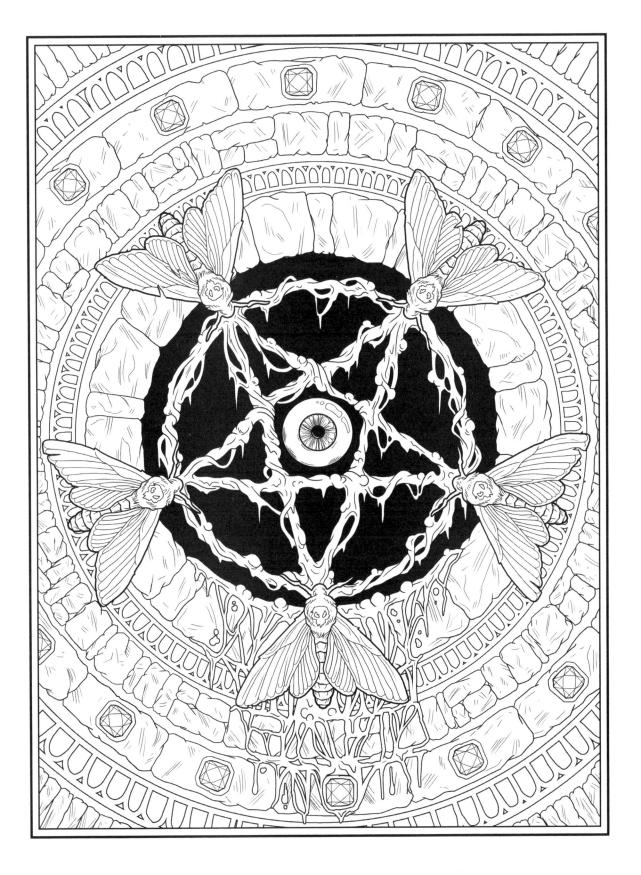

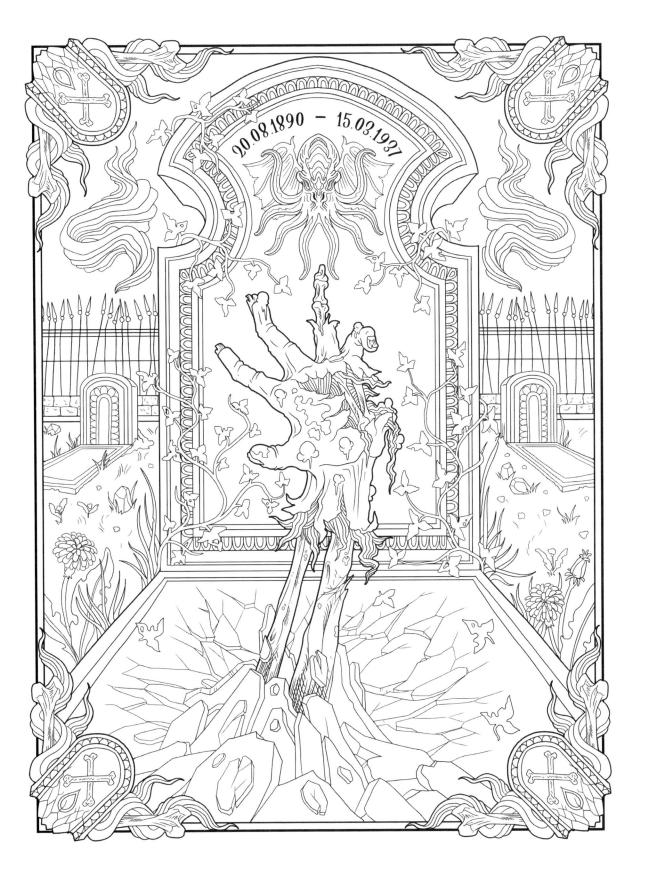

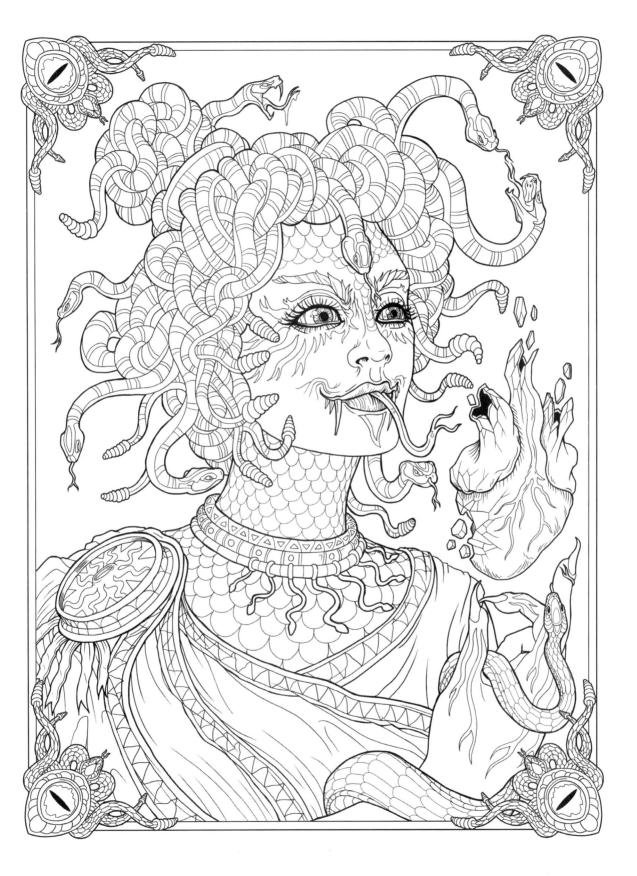

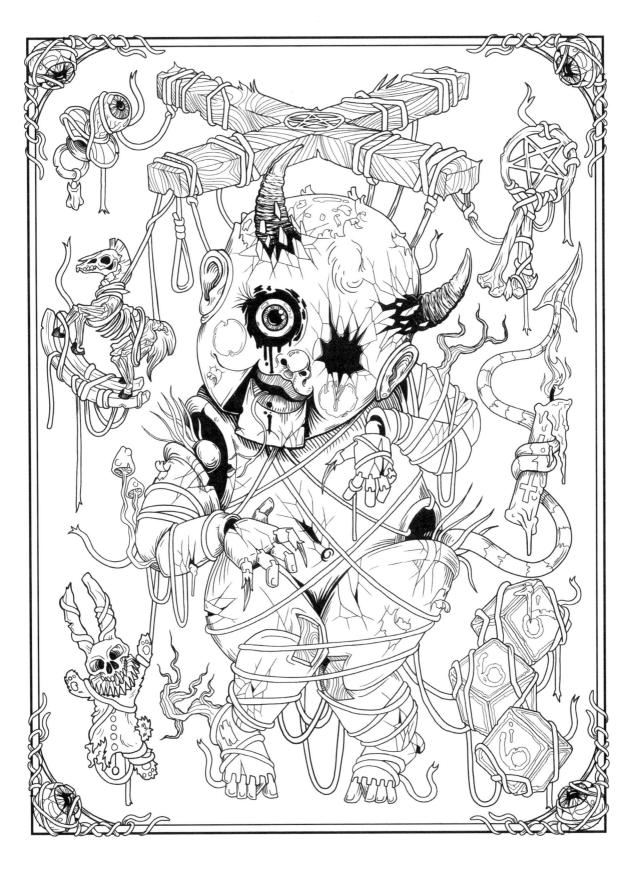

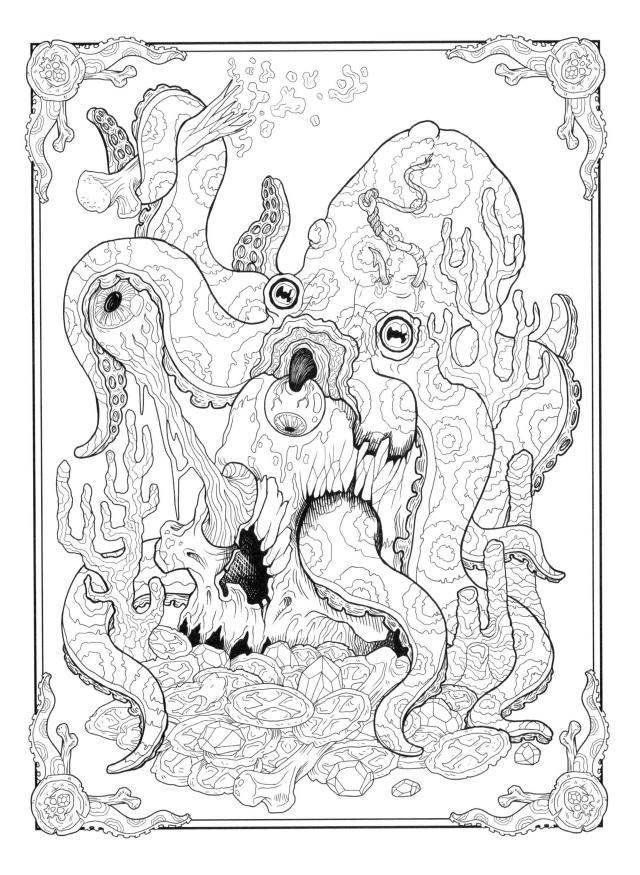

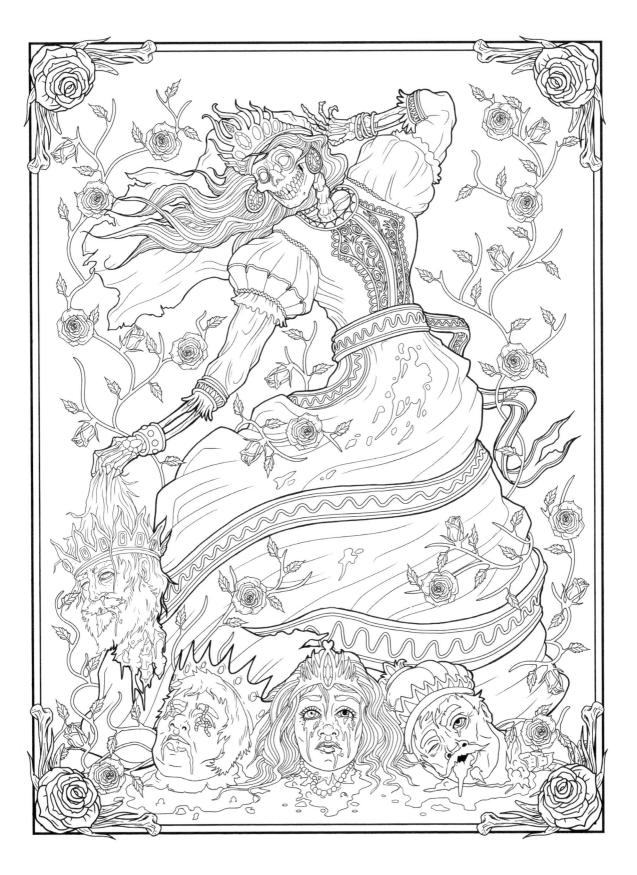

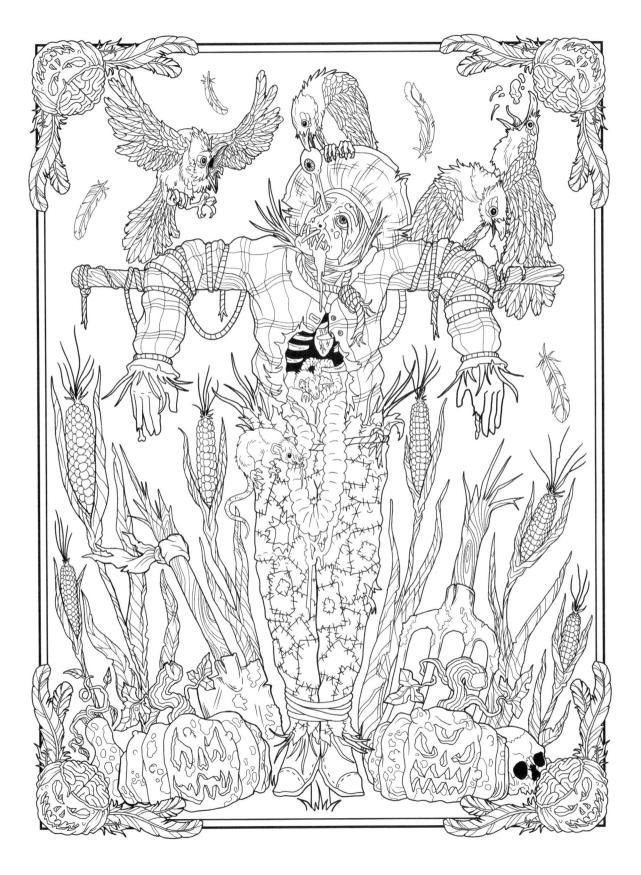

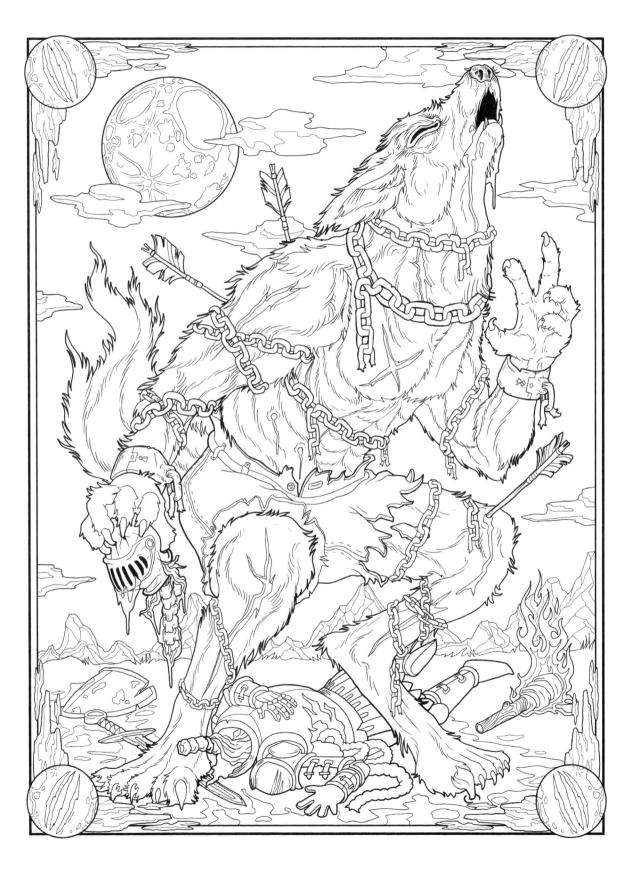

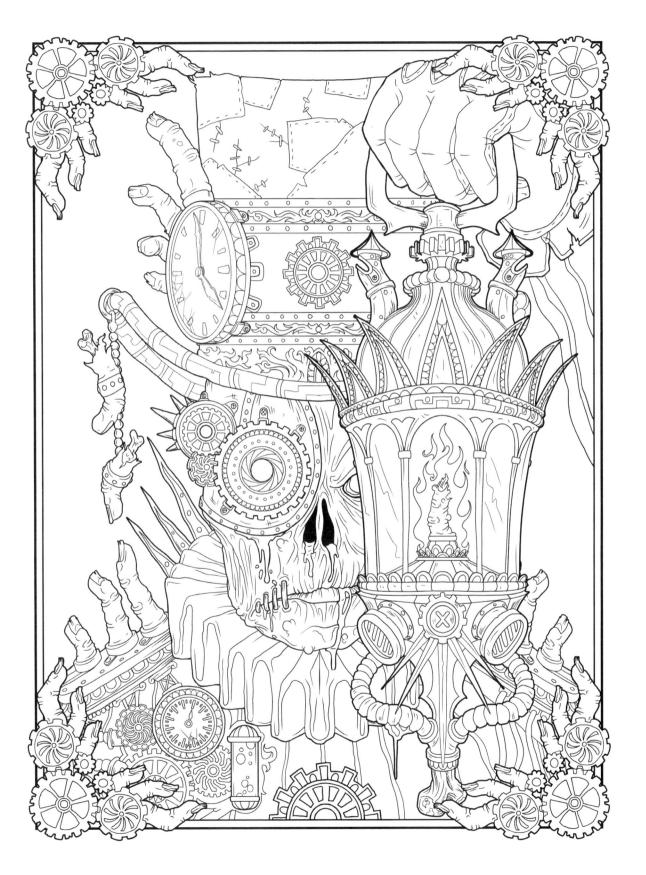

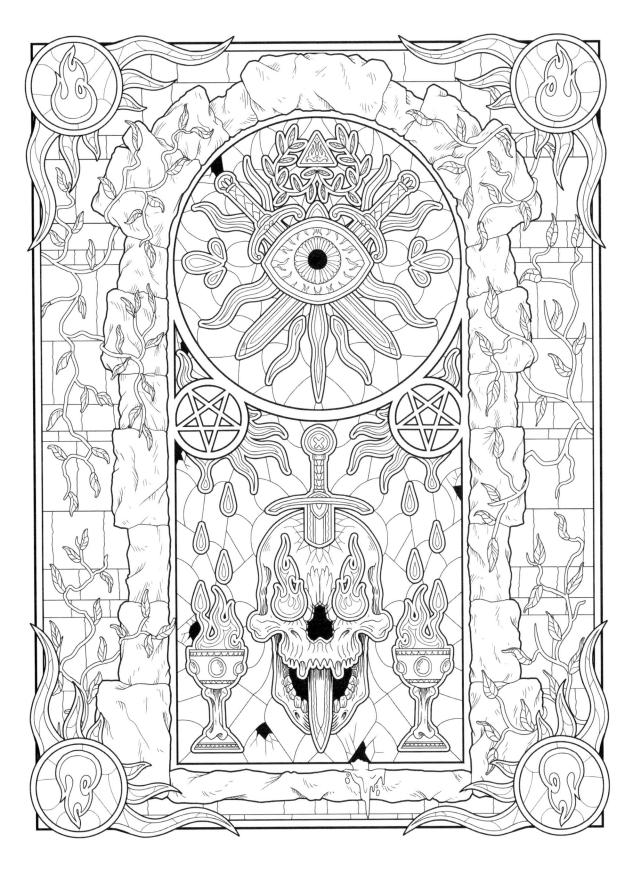

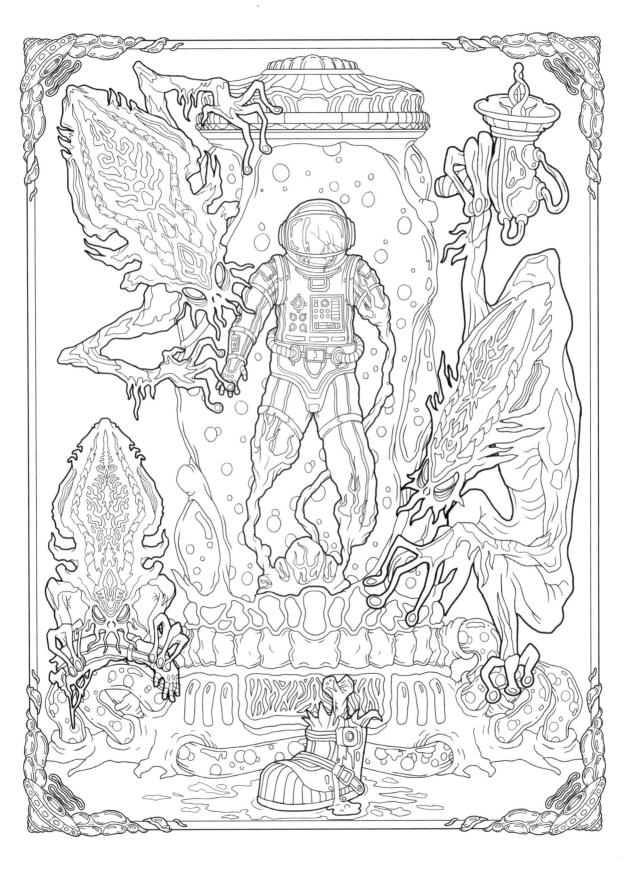

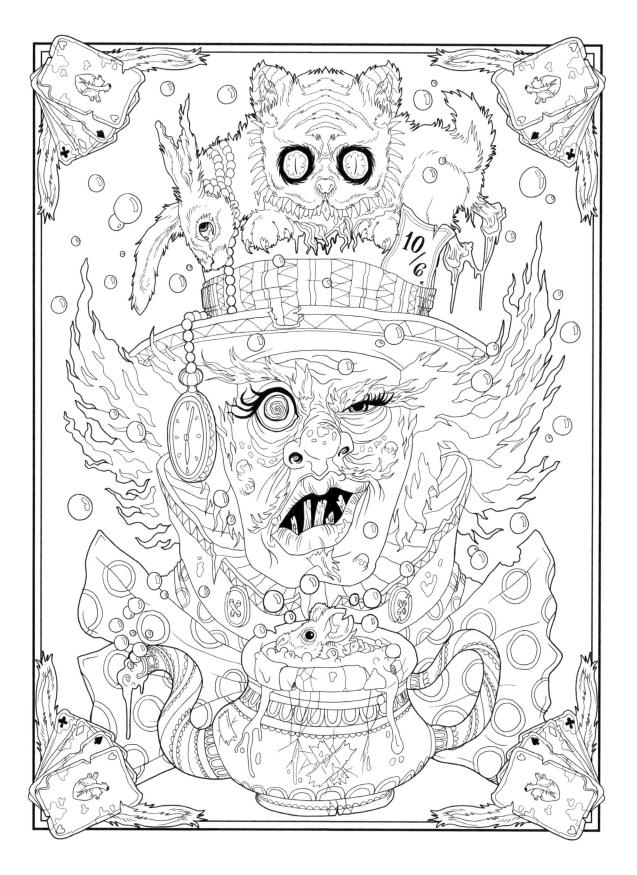

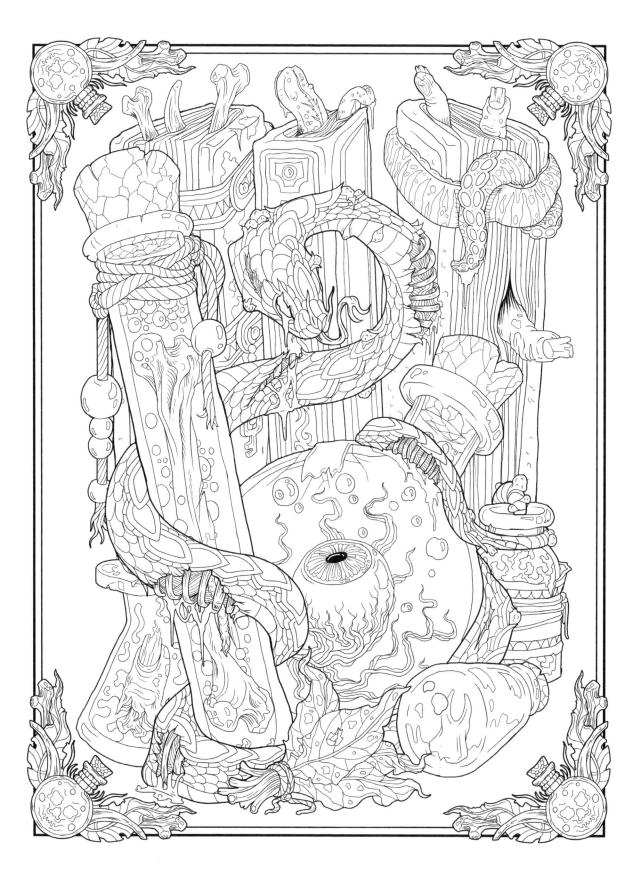

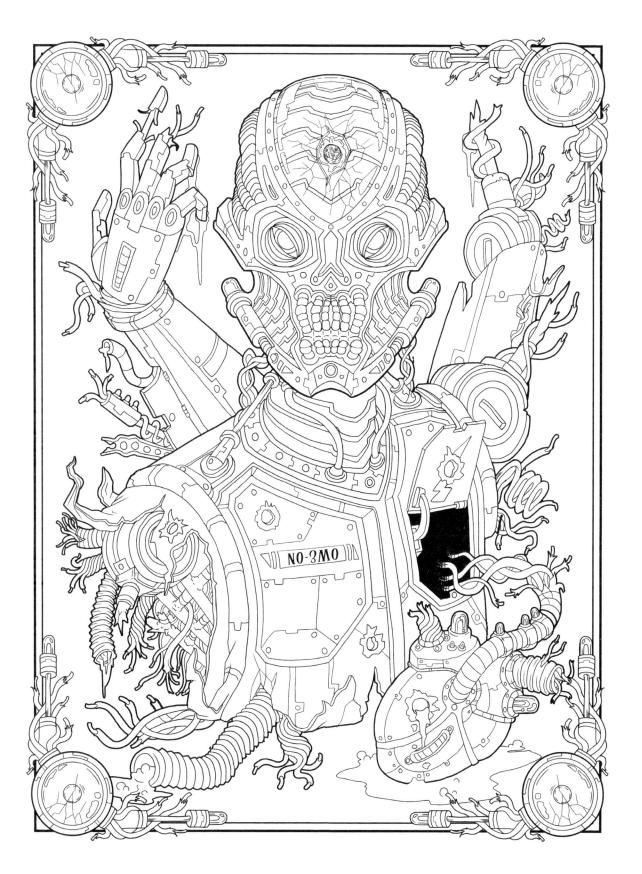

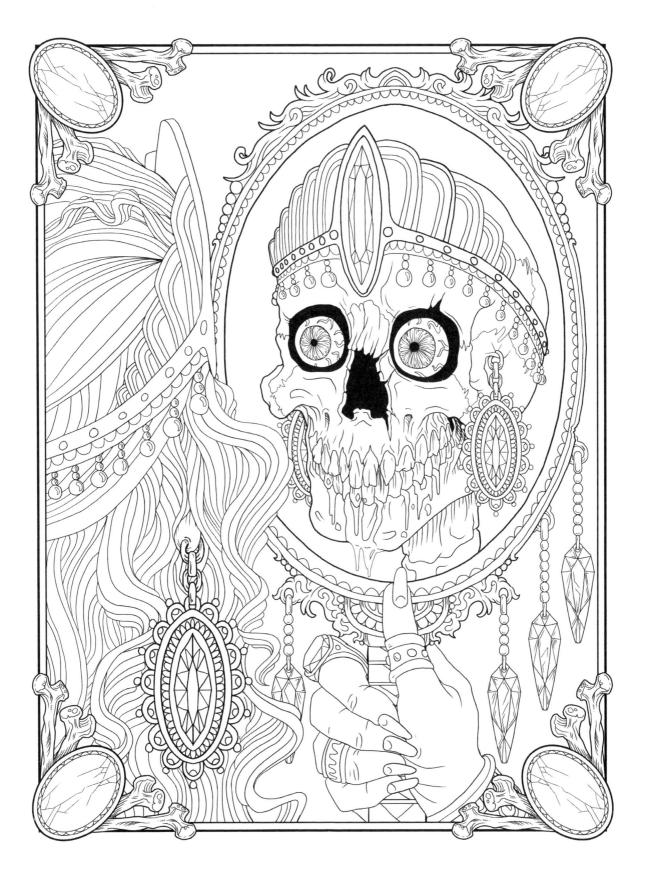

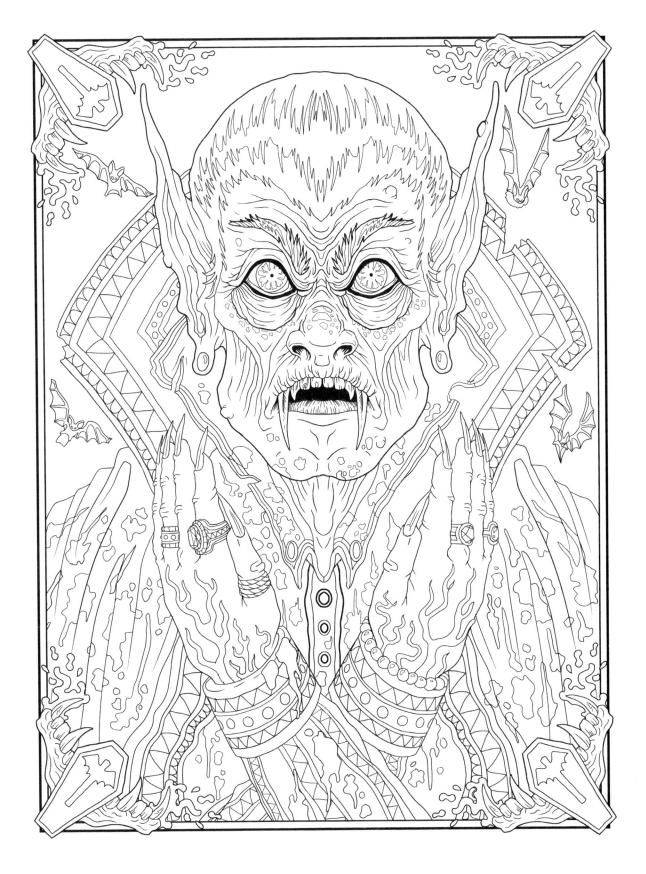

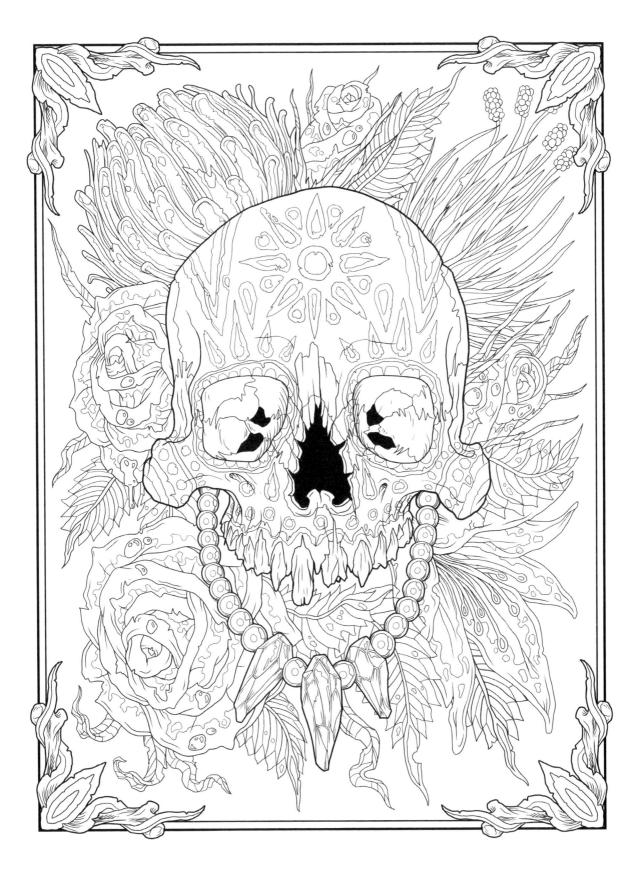

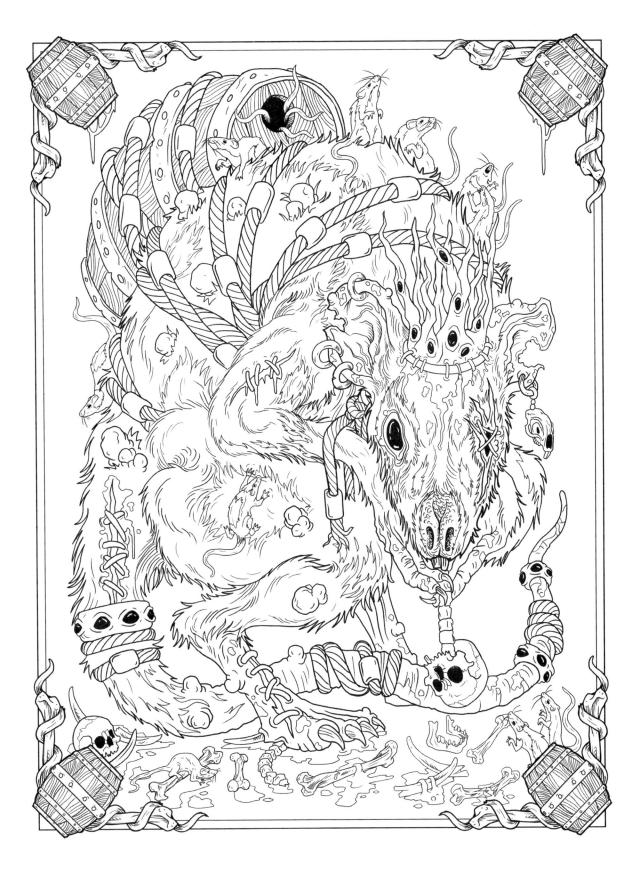

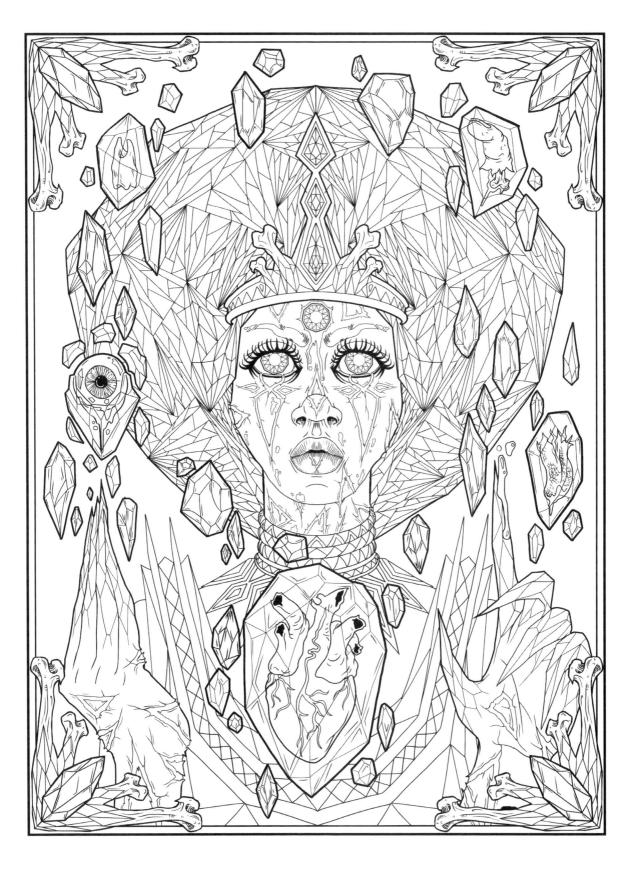

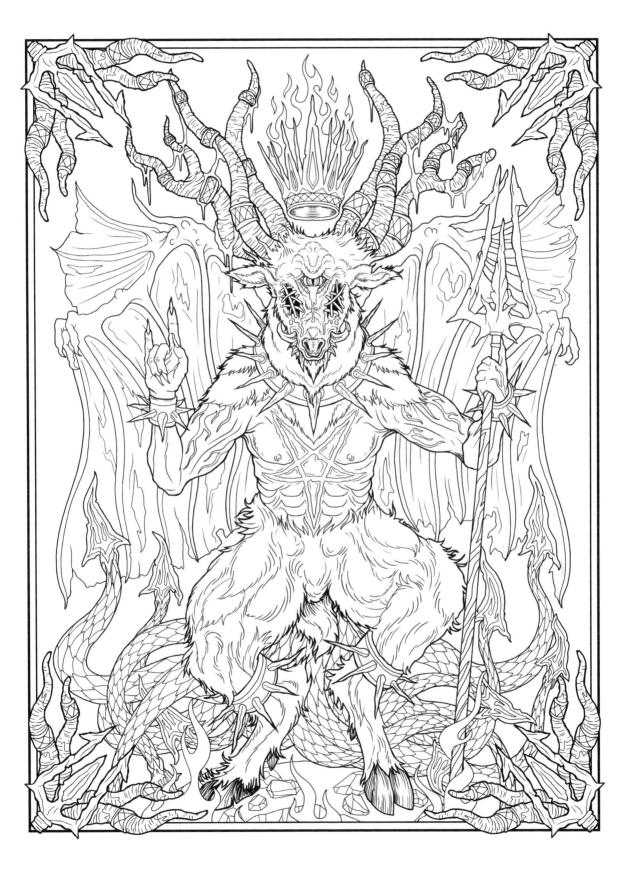

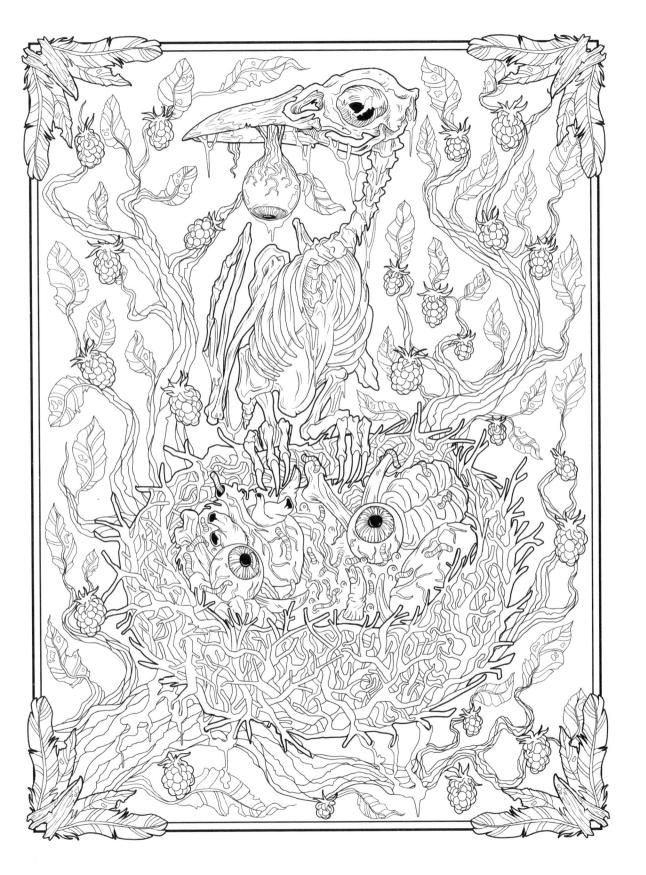

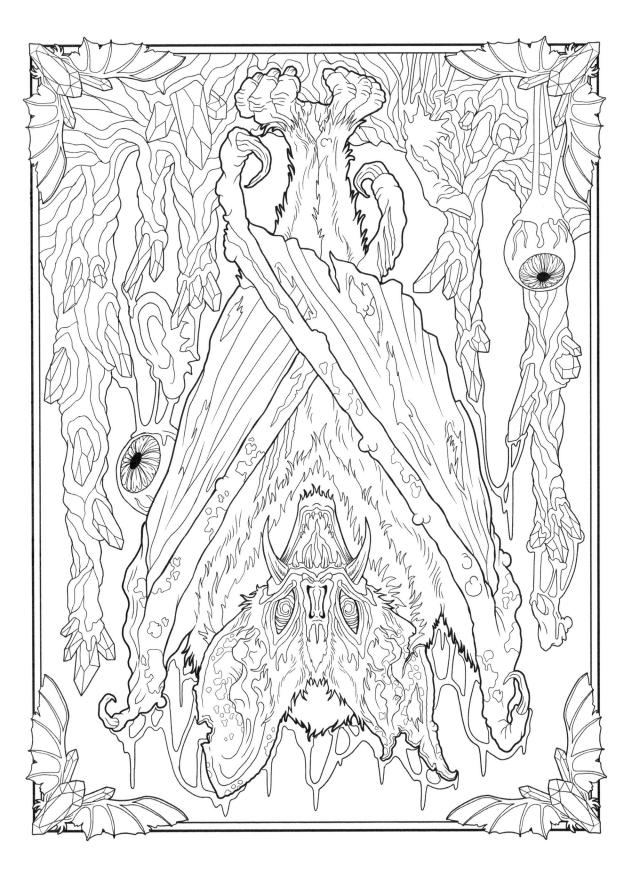

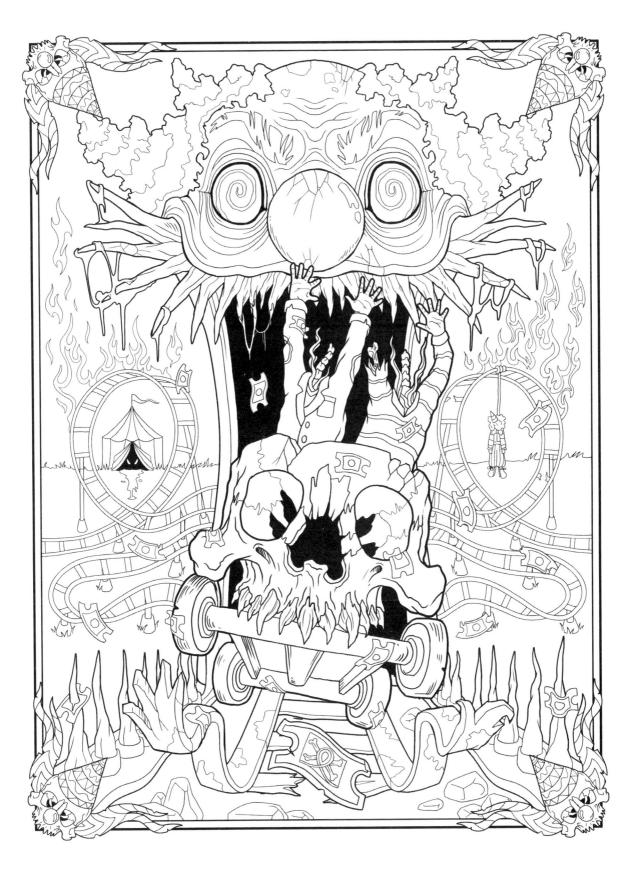

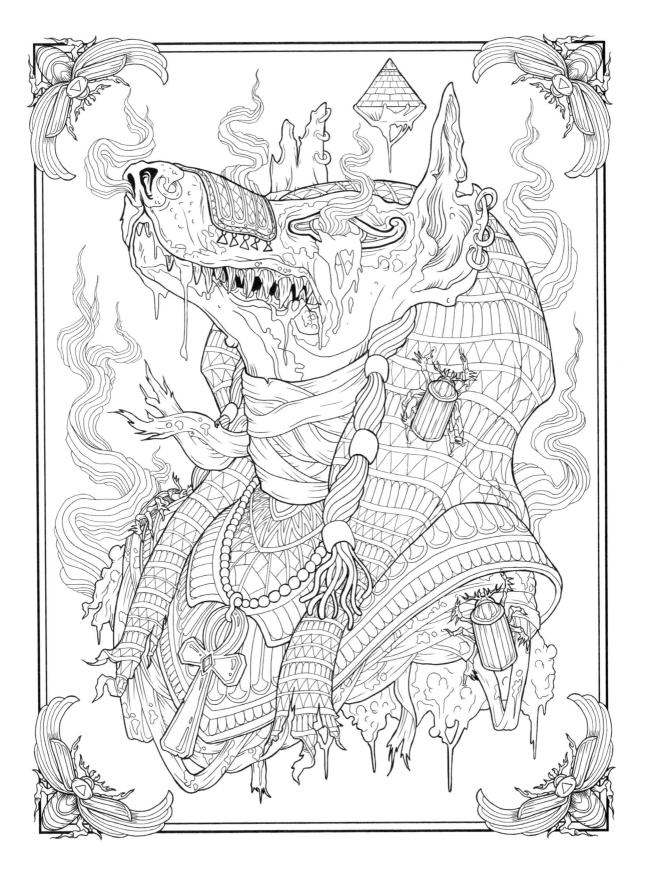

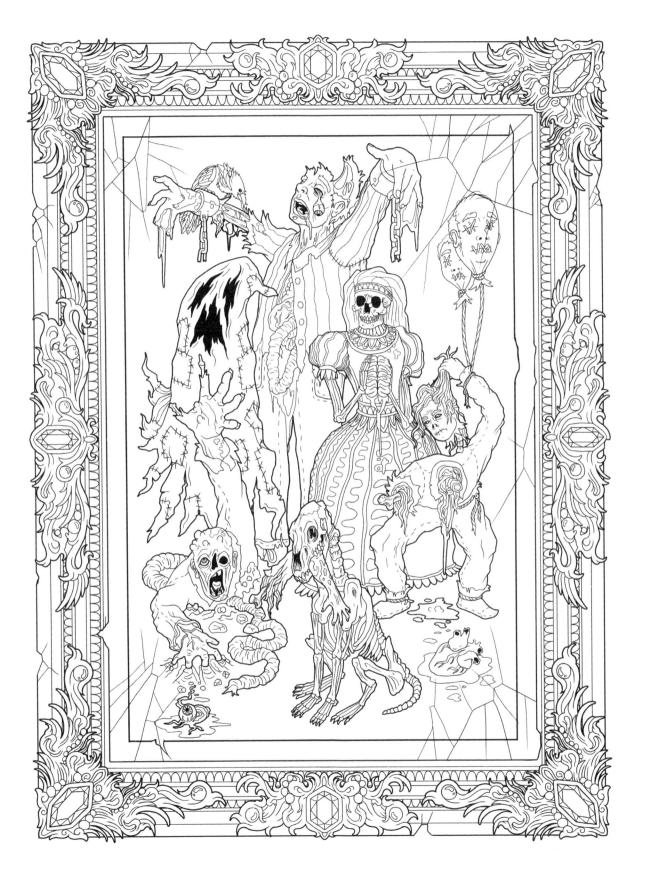

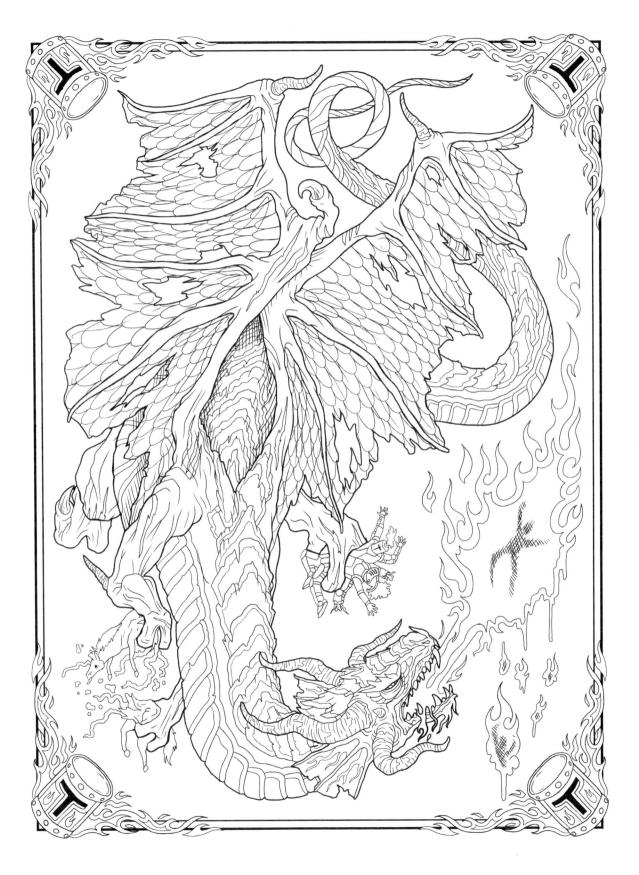

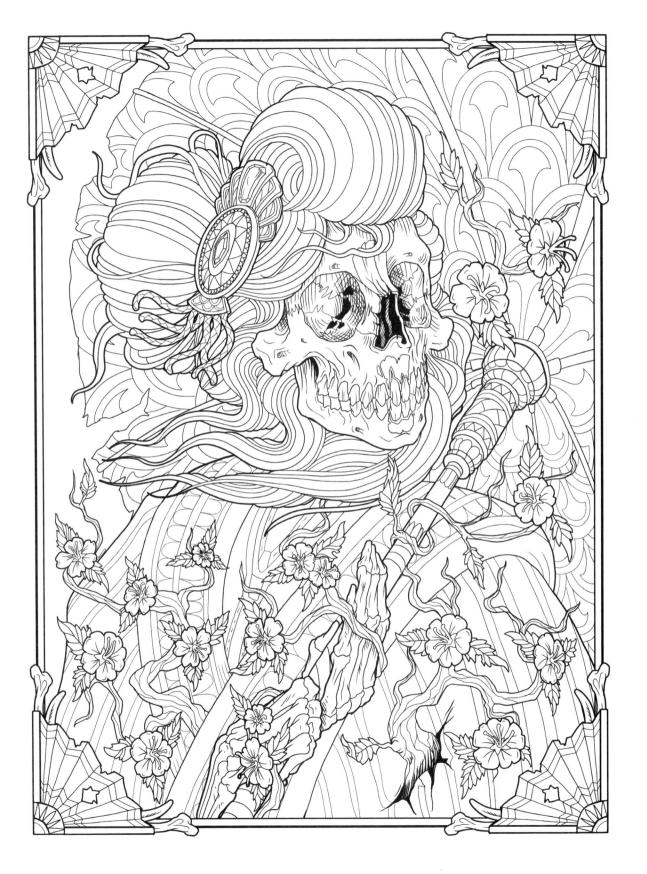